THE EIFFEL TOWER

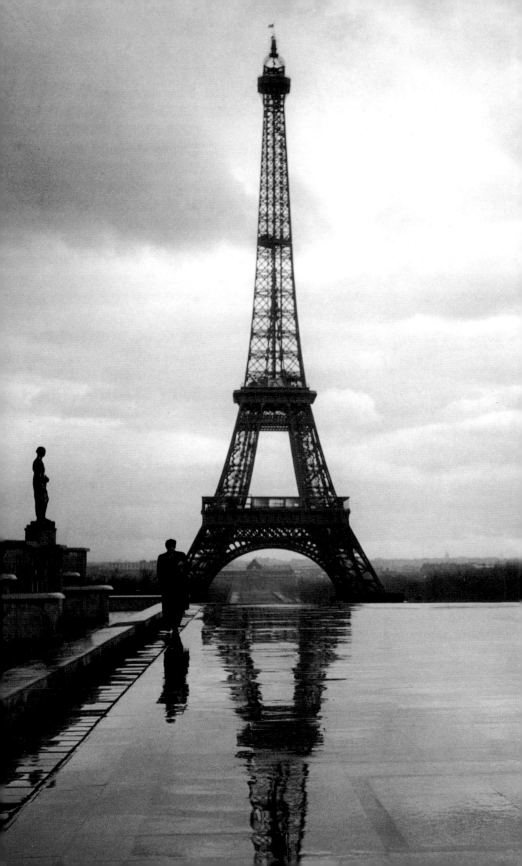

THE EIFFEL TOWER

PHOTOGRAPHS BY
LUCIEN HERVÉ

INTRODUCTION BY
BARRY BERGDOLL

PRINCETON ARCHITECTURAL PRESS ✳ NEW YORK

Published by
Princeton Architectural Press
37 East Seventh Street
New York, New York 10003

For a free catalog of books, call 1.800.722.6657.
Visit our web site at www.papress.com.

Editing and design: Mark Lamster
Proofreading: Noel Millea

Special thanks: Nettie Aljian, Ann Alter, Nicola Bednarek, Janet Behning, Megan Carey, Penny Chu, Russell Fernandez, Clare Jacobson, Nancy Eklund Later, Linda Lee, Jane Sheinman, Katharine Smalley, Scott Tennent, Jennifer Thompson, Joe Weston, and Deb Wood of Princeton Architectural Press—Kevin C. Lippert, publisher

Library of Congress Cataloging-in-Publication Data for this title is available from the publisher.

CONTENTS

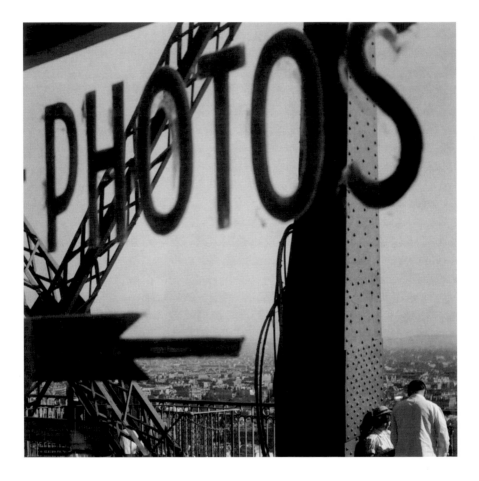

INTRODUCTION

BARRY BERGDOLL

OF THE GREAT twentieth-century photographers who have made us look afresh at the Eiffel Tower, one of modernity's most clichéd images, Lucien Hervé has remained uniquely faithful to Gustave Eiffel's creation. While most photographers engage with an architect's work for an intense but limited period, Hervé's entire career has been punctuated by Paris's most famous modern structure. As the tower itself has shifted from an avant-garde symbol to a beloved and ubiquitous tourist attraction, Hervé has returned over and over again to its iron filigrees, its shadows, and its reflections.

Born in Hungary in 1910, Laszlo Elkan trained as an artist in Vienna before moving to Paris in 1929, where he worked in the fashion industry. He found his true calling in 1938 while shooting images of the Eiffel Tower that he hoped might form the basis for a photo essay on the tower's approaching fiftieth anniversary. A decade later, under the name Lucien Hervé—a pseudonym adopted for survival as a member of the French Resistance and never abandoned—he returned to the tower to renew his artistic career, as he would time and time again, sometimes shooting it as part of an ongoing independent project, sometimes catching it on the horizon as he was fulfilling a commission from one of the architects who made his one of the most successful architectural photography practices in postwar Europe; Hervé was commissioned to document the work of such revered

masters as Le Corbusier, Alvar Aalto, and Marcel Breuer.[1] This book, with its selection of images of the Eiffel Tower taken over nearly half a century, is in some ways a fulfillment of the personal project Hervé began in 1938.[2]

Constructed with breathtaking speed in the twenty-seven months leading up to the opening of the 1889 Exposition Universelle, on 6 May, the tower was one of the most photographed buildings in Paris, if not the world, even before its much-marveled elevators first took visitors to the summit. Like photography, which celebrated its first half century at the fair, the 300-meter cast- and wrought-iron tower aroused enormous anxieties over the aesthetic merit of an art that took form with industral materials and processes rather than through handicraft.[3]

From the outset, the design was mired in controversy. Plans for a world's fair to coincide with the centennial of the French Revolution served as a lightening rod for the polarized visions of France in the 1880s. Politically, the fair was associated with the Republican left, who had recently taken the reigns of the none-too-stable Third Republic and saw the fair as an instrument for solidifying their vision of a progressive, secular state and as a boost to a faltering economy. The project was so stamped with Republican ideology that it was boycotted by most of Europe's monarchs, although Britain's Victoria and her son, the future George V, visited the tower before the fair opened to the public.

Two engineers from Eiffel's construction firm—already respected for daring iron railroad bridges and prefabricated buildings—as well as the architect Jules Bourdais had drawn up schemes for lofty towers even before the government announced a specific architectural program and site for the fair, on 1 May 1886. A competition was opened, and despite a much ridiculed deadline of two weeks for filing projects, over 700 tower schemes were submitted. Critics

questioned whether the Champ de Mars, former exercise ground of the Ecole Militaire, was an appropriate site, and lambasted so many towers of Babel.[4] But the Eiffel proposal won the day, and was passionately defended by its advocates. As Jules Simon, Minister of Fine Arts, wrote in the *Guide officiel de la Tour Eiffel* (the Eiffel name already having superceded Republican ambitions to name the tower for the Revolution), "this masterpiece of the builder's art comes at its appointed hour, on the threshold of the twentieth century, to symbolize the age of iron we are entering. From the second platform, and, above all from the upper-most, a panorama unfolds such as has never been seen by human eyes....Nature and history are unrolled side by side in their most powerful guise. It is on the plain, stretched out beneath your feet, that the past comes to an end. It is here that the future will be fulfilled."[5]

Construction began in late January 1887. Foundations were complete on 30 June and assembly of the iron parts fabricated in Eiffel's factories at Levallois-Perret, an industrial suburb downriver from Paris, began the following day. By 1 April 1888 the first floor had been completed; the second followed on 14 August, and by 31 March 1889 assembly of the lantern, to be lit with powerful electric floodlights—one of the great novelties of the exhibition—was complete.

But even as the tower pushed toward the clouds, a chorus of opposing voices rose in protest, attacking it as a meaningless gesture, devoid of function and too reminiscent of an industrial smokestack. A petition signed by prominent writers, musicians, artists, and architects questioned the tower's right to a permanent place in the skyline of a city whose grand axes were still being fine-tuned by Baron Haussmann's successors. "Passionate devotees of the hitherto untouched beauty of Paris...protest with all our strength, with all our indignation, in the name of slighted French taste, in the name of the threatened art and history

of France, against the erection, right in the heart of our capital, of the useless and monstrous Eiffel Tower," wrote Charles Gounod, Guy de Maupassant, Victor Bouguereau, and the architects Charles Garnier and Emile Vaudremer among others. "Is the city of Paris then going to associate herself...with the grotesque, mercenary invention of a machine builder, so as to deface and deflower herself? For you may not doubt that the Eiffel Tower, unwanted even by commercial America, is the deflowering of Paris."[6]

The petition provoked Eiffel to formulate both an artistic position for what he now considered to be his tower and an argument that was to make him a grandfather figure among functionalist theorists in the modern movement. "Is it because we are engineers that we do not pay attention to beauty?" Eiffel responded. "Do not the laws of natural forces always conform to the secret laws of harmony? The first principle of the aesthetics of architecture is that the essential lines of a monument should be determined by their perfect appropriateness to their end. Now, what condition do I have to take into consideration above all others in a tower? Wind resistance. Well I maintain that the curves of the four arrises of the monument, as the calculations have determined them, will vie an impression of beauty because they will demonstrate to the viewer the boldness of the conception."[7]

As the self-appointed publicist and defendant of the tower, Eiffel assumed an authorial role for a design that was not truly his, and that he had initially treated with indifference. Drawn up by two engineers at Eiffel & Co., Emile Nougier and Maurice Koechlin, the overscaled pylon was in fact a logical extension of the research into structure and fabrication that had made possible the firm's most successful projects of the previous decade, most famously the monumental railroad viaduct at Garabit in the Massif Central (1879-84).[8] Koechlin did the calculations at home, and drew up

a sketch in which he showed a 300-meter pylon surpassing the combined height of Notre Dame Cathedral, the Statue of Liberty, the Bastille Column, the Arc de Triomphe, and several other world landmarks all stacked up on the margins of the page. The Eiffel firm's staff architect, Stephen Sauvestre, added the great spanning arches between the four "feet" of the tower in an effort to dramatize the visual impression of stability, to turn the tower into a gateway for the exhibition, and to frame views of the Ecole Militaire and the Palais de Trocadéro (today the remodeled Palais de Chaillot) on the other bank of the Seine, the endpoints of the monumental landscaped axis on which the tower sits. Sauvestre also suggested a great glazed reception room on the first terrace, and sculptural decorations added to the second stage, for which they hoped to commission Frédéric Auguste Bartholdi, with whom the Eiffel firm had worked on the Statue of Liberty.

Invited to exhibit the project at the 1884 annual exhibition of decorative arts, Koechlin and Nougier showed the project to Eiffel, whose interest was at last peaked. He gave it his blessing and in their joint names filed for a patent, issued on 18 September. Three months later, Eiffel quietly bought out his associates' interests in the patent, and in contract negotiations with the city of Paris assumed personal liability in exchange for a twenty-year license to run the tower.

In 1900, as projects were under review for transforming the tower for that year's Exposition Universelle, Eiffel published an exhaustive two-volume folio in celebration of the tower as part of his ongoing battle to make the tower permanent. He included the calculations that had gone into the tower's design and page after page of poems, drawings, and letters he had assembled as a private museum of the tower's enormous popularity and hold on the public imagination. Alongside the artists' petition against the tower, repro-

duced in full, Eiffel placed famous signatures from the tower's visitors book, including that of Thomas A. Edison: "To M. Eiffel, the Engineer, the brave builder of so gigantic and original a specimen of modern engineering from one who has the greatest admiration for all Engineers including the great Engineer le bon Dieu."[9]

Artists took the lead in promoting the Eiffel Tower as a crucible of modernism. In 1888, as completion was near, Georges Seurat rendered the tower in his divisionist vocabulary, suggesting that the open filigree was an ideal figure for a new way of viewing the world. Henri Rivière's images of workers on the tower's permanent scaffolds developed a whole new aesthetic for photographic composition. Rivière's lithographic *Thirty-six views of the Eiffel Tower under construction* (1888–1902) are at once an homage to Hokusai and to Eiffel, and presage one of Hervé's fundamental strategies: the use of closely cropped fragmentary views of the tower's profile to stand in for the whole. But it was the artist Raymond Duchamp-Villon, in his 1913 campaign to save the tower from proposed demolition, who first formulated in words the new status of Eiffel as a prototype of the modern artist throwing off the chains of academic culture: "Is not one of the best conditions for projecting and realizing a masterpiece an ignorance of all known artistic laws, an ignorance which frees a man to obey the joy of creating and following his sense of an ideal?"[10]

In the end, the tower was saved by the First World War, when Eiffel persuaded the city of Paris of its usefulness as a radio and telegraphic post. No less timely was Le Corbusier's publication in 1923—the year of Eiffel's death—of photographs of the tower and of the viaduct at Garabit to illustrate his thesis of "The Engineer's Aesthetic" in *Towards a New Architecture*, just as the state was considering a proposal to reuse the tower's iron for rebuilding factories in industrial regions devastated by the war.

For the 1937 Paris Exposition Universelle, Le Corbusier arranged a display within a window frame of the newly remodeled Palais de Chaillot framing a view to the Eiffel Tower. There he placed a copy of the artists' petition between two of his own drawings of Paris done during lectures in Buenos Aires; here the profile of the Eiffel Tower structured the city and next to it the architect had scrawled "Ça, c'est Paris."[11] The Eiffel Tower that Hervé photographed for the first time the following year was newly remodeled and modernized, the fanciful cornice of scalloped windows ringing the first terrace having been replaced by a hard-edged canopy.

By the time Hervé—having escaped a German prison camp, fought in the Resistance, and been excluded twice from the French Communist Party—returned to photography and to the tower, in 1947, a whole new layer of meaning had accrued to Paris's famed monument. Roland Barthes would later describe the tower as an "almost empty sign," but it is revealing when looking at Hervé's postwar images, with their insistence on the human presence in the tower and in the city surrounding it, to remember the Germans' emphatic occupation of the tower. On his sole visit to Paris, in June 1940, Hitler had himself photographed with the tower as a backdrop; soon thereafter the shaft was adorned with an enormous *V* and the first terrace was bedecked with a banner declaring "Deutschland Siegt auf Allen Fronten" ("Germany Is Victorious on All Fronts"). French workers had sabotaged the elevators as they ceded the tower, but in August 1944 an employee fixed them with the turn of a screwdriver when the tower was opened to free visits for allied soldiers.

"In every heart, the sign of beloved Paris, the beloved sign of Paris," Le Corbusier wrote in his preface to a book on the Eiffel Tower in 1955.[12] By then Le Corbusier's work was as thoroughly intermeshed with the myth of the nineteenth-century engineer as it was with the vision of a photographer

who had developed an equal fascination for the tower: Lucien Hervé.[13] The intermediary was the Dominican priest Père Couturier, a force behind the renewal of ecclesiastical art and architecture in postwar France. Couturier was editor of the magazine *L'Art Sacré*, on whose cover Hervé had published a photograph of the Eiffel Tower in a 1950 special issue devoted to "L'Art Profane." A year earlier Couturier urged Hervé, to whom he had already entrusted the privilege of photographing the reclusive Henri Matisse at work on the chapel at Vence, to undertake a reportage on Le Corbusier's housing block then under construction at Marseilles. Adjacent to juxtaposed photographs of the Eiffel Tower's structure and Hervé's close-ups of the powerful inclined piloti of the Unité d'Habitation, Couturier argued for a personal purification through the "restoration of visual sensitivity," and explained: "We recall that forms worthy of admiration are always born without any concern for art from the strict rigor of calculations and for the healthy attention to functions and to ends."[14]

In Couturier's milieu, both Le Corbusier and Hervé carved out positions that resolved a belief in pure form with a commitment to an ethics of artistic practice. Hervé established an autonomous position for commissioned photography by fragmenting another artist's work into multiple viewpoints and unexpected close-up details, each ruled by geometric convention and patterns of light and shadow—architecture depicted as an event.[15]

Over the course of the next decade, Hervé photographed the tower from within and from a distance, catching amateur photographers with their lenses trained on the lofty iron filigree as well as its reflection on panes of glass far from the actual structure. The theme that unites these images is the ubiquity of the tower in the topography and daily life of Paris. Photography itself becomes a theme. Finding the tower again in his viewfinder as he took up the

assignment of documenting the construction of UNESCO's new headquarters between 1955 and 1957, Hervé engaged in the first great postwar polemic on the introduction of modern architecture into the historic heart of Paris. The Eiffel Tower had been used by the Commission on Sites and Perspectives to justify a steel and concrete frame building on one of the most prominent sites of the capital. UNESCO's curved office block, a lightweight steel frame raised on Corbusian pilotis, is subtly contextual, inflected just enough to form the missing half of the semicircular Place de Fontenoy that the eighteenth-century architect Jacques-Ange Gabriel had projected as the foreground to his Ecole Militaire. Obscured from this classical set piece of grand urbanism, UNESCO's architects—Marcel Breuer and Bernard Zehrfuss, working with the Italian engineer-architect Pier Luigi Nervi—placed the organization's conference building, a daring span of prestressed concrete trusses carried above great walls of folded concrete. In Hervé's photographs, both the powerful forms of the conference building and the delicate movement of Alexander Calder's stabile—chosen by Breuer for UNESCO's grounds—are placed into a taut dialog with Eiffel's tower (see pages 21, 22–24, 26–27).

UNESCO was the most controversial architectural project of its time in France. "It has probably aroused more strong feeling than any building since the Eiffel Tower, for it upsets preconceived notions and disturbs conventional ways of seeing, thinking, and living," wrote the architectural historian Françoise Choay.[16] This was precisely what the Eiffel Tower had done for so many in its early years, and perhaps for no artist more than Laszlo Elkan in 1938. In a very real way, Eiffel's tower had been nothing less than a catalyst for the invention of the photographer Lucien Hervé.

15

NOTES

1. For an overview of Hervé's photography, see Olivier Beer, *Lucien Hervé, L'Homme Construit* (Paris: Seuil, 2001) and the exhibition catalog, Tjeerd Boersma (ed.), *De essentie van het fragment: Architectuurfoto's van Lucien Hervé* (Rotterdam: NAI, 1992).

2. That project was continued for the centennial of the tower by Hervé's son, Rodolf Hervé. See *Rodolf Hervé* (Székesfehérvár, Hungary: Szent István Király Múzeum, 2001).

3. For the most insightful analysis of this history see Henri Loyrette, "La tour Eiffel," in Pierre Nora, ed., *Les lieux de mémoire* vol. 3 (Paris: Gallimard Quarto, 1997), 4270–93.

4. *La semaine des constructeurs* 10 (8 May 1886): 537, quoted in Caroline Mathieu, ed., *1889: La Tour Eiffel et l'Exposition Universelle* (Paris: Réunion des Musées Nationaux, 1989), 17.

5. Quoted in Henri Loyrette, *Gustave Eiffel* (New York: Rizzoli, 1985), 174.

6. "Pétition des artistes adressée à Alphand," published originally in *Le Temps*, 14 February 1887, reprinted in Mathieu, *1889*, 28. The voice of Garnier, whose Opéra had hidden its many miles of iron construction under an overlay of stone, sculpture, mural, and mosaic, is clearly heard in this salvo, the first of many against those hoping to introduce signs of industry inside the harmonious vistas of Paris—including Hector Guimard and his cast-iron métro entrances of the 1890s.

7. Manuscript notes quoted by Loyrette, *Gustave Eiffel*, 176.

8. For an overview of the Eiffel firm see Loyrette, *Gustave Eiffel*; Bertrand Lemoine, *Gustave Eiffel* (Paris: Hazan, 1984); and Bernard Marrey, *The Extraordinary Life and Work of Monsieur Gustave Eiffel* (Paris: Graphite, 1984).

9. Eiffel, *La Tour de Trois Cents Metres* (Paris: Société des imprimeurs Lemercier, 1900) vol. 1, n.p., entry for 10 Sept. 1889. Quoted in Adolf Placzek and Angela Giral, eds., *Avery's Choice: Five Centuries of Great Architectural Books* (New York: G.K. Hall, 1997), 214.

10. Raymond Duchamp-Villon, *L'Architecture et le Fer: La Tour Eiffel* (Paris: L'Échoppe, 1994), 13; originally published in *Poème & Drame, Atlas internationale des arts modernes*, 2e série, vol. VII, Jan.–Mars, 1914, and dated by Duchamp-Villon Nov. 1913. Extract also published in Mathieu, *1889*, 42.

11. Le Corbusier, preface to *Charles Cordat, La Tour Eiffel* (Paris: Les Editions du Minuit, 1955), 8.

12. Ibid.

13. Le Corbusier also provided the preface—and the title to the new edition—to Hervé's study of the Cistercian Abbey of Le Thoronet, *La plus grande aventure du monde: l'architecture mystique de Cîteaux* (Paris: Cali, 1956). Reprinted as *Architecture of Truth: the Cistercian Abbey of Le Thoronet*, New York: Phaidon, 2001).

14. Père Couturier, "Pour les Yeux," *L'Art Sacré* 5–6 (Jan.–Feb. 1950): 20–5.

15. For a rare statement of Hervé's artistic philosophy, see: Lucien Hervé, "A propos de le photographie d'architecture," *Aujourd'hui, Art et Architecture* 9 (Sept. 1956): 30.

16. Françoise Choay, introduction to *Le Siège de l'Unesco à Paris* (Paris: Vincent Freal, 1958).

PHOTOGRAPHIC PLATES

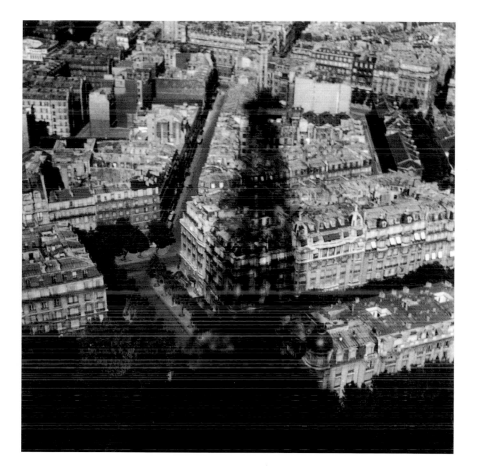

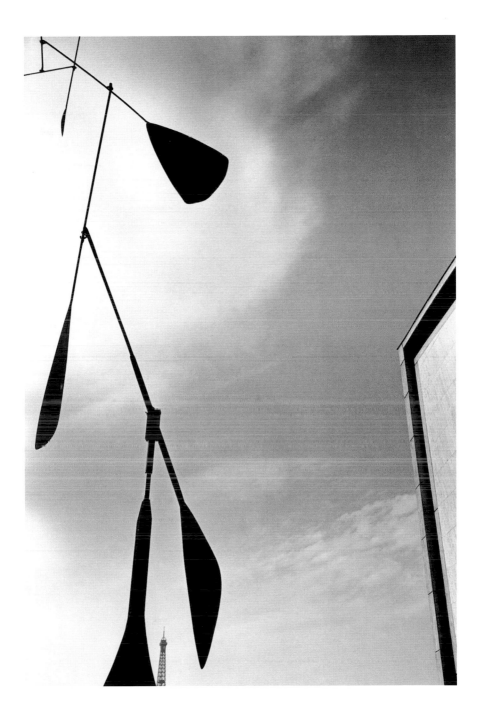

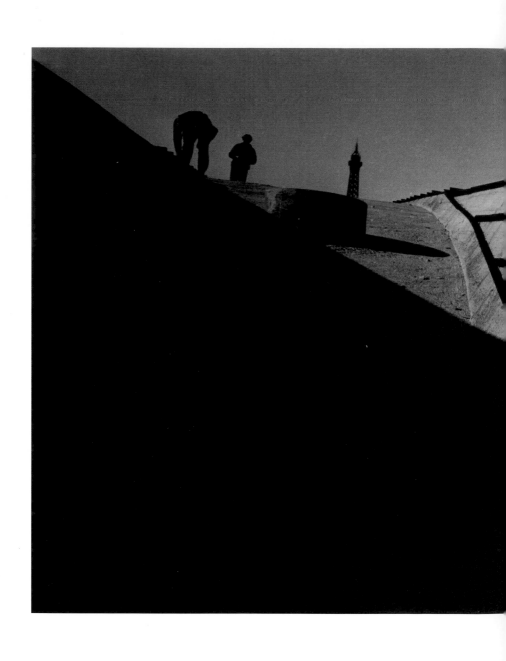

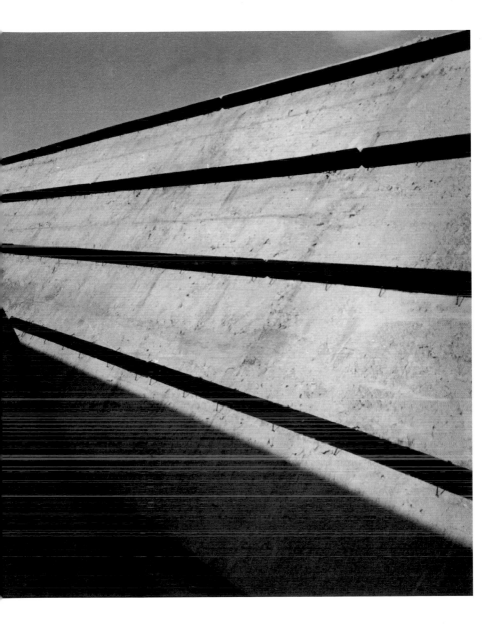

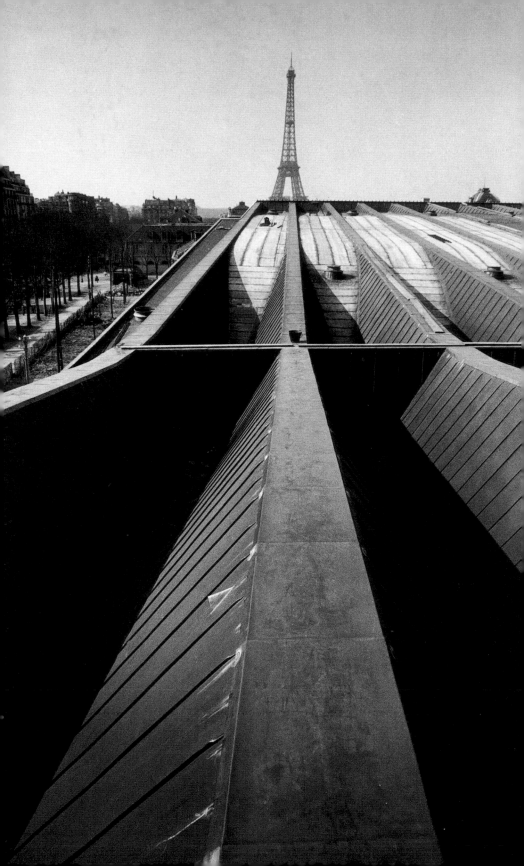

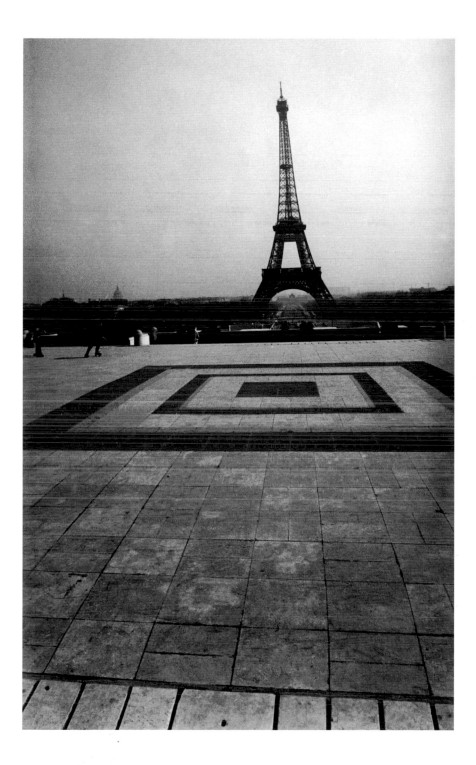

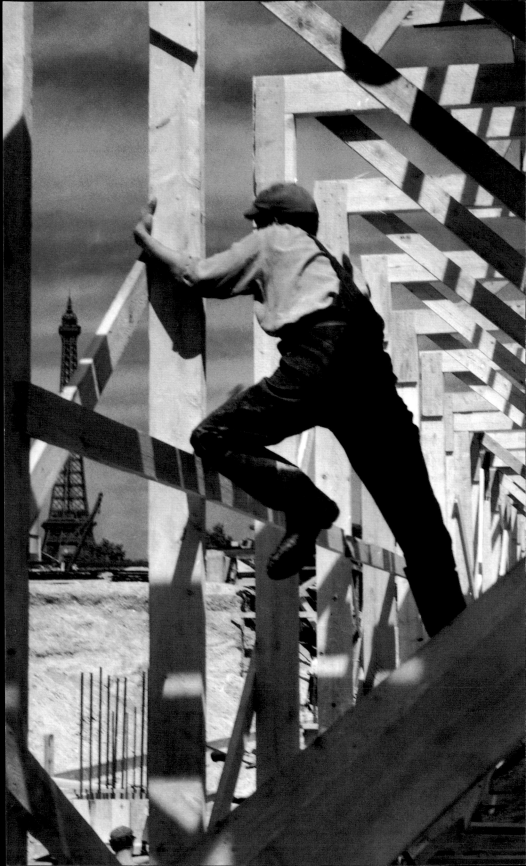

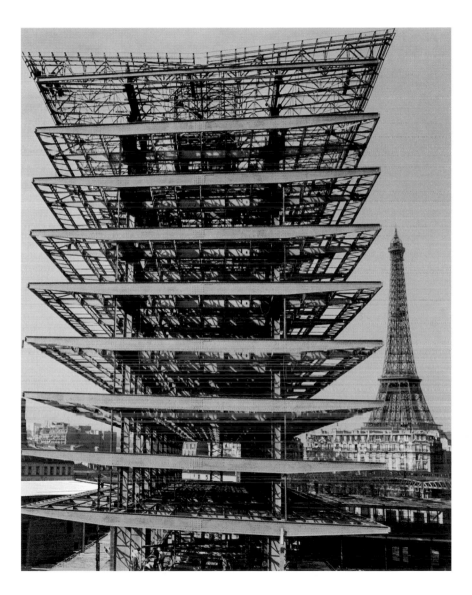

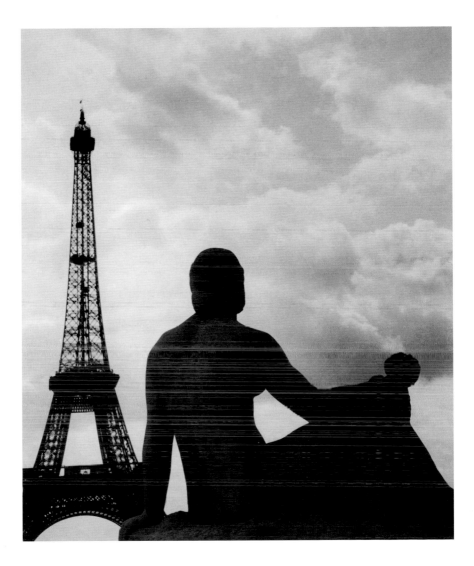

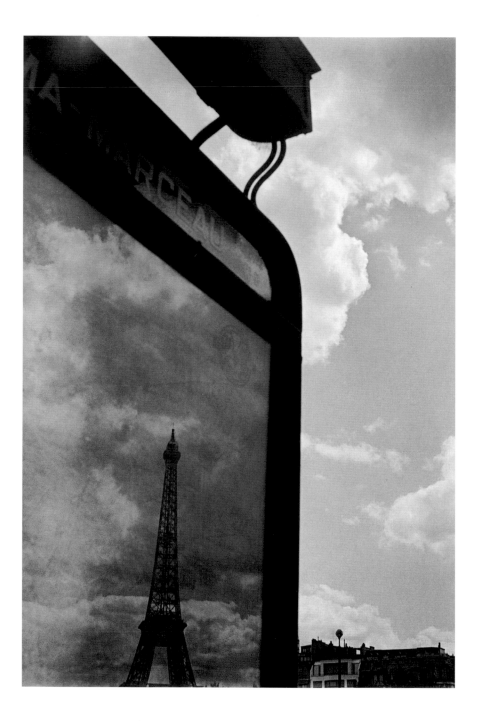

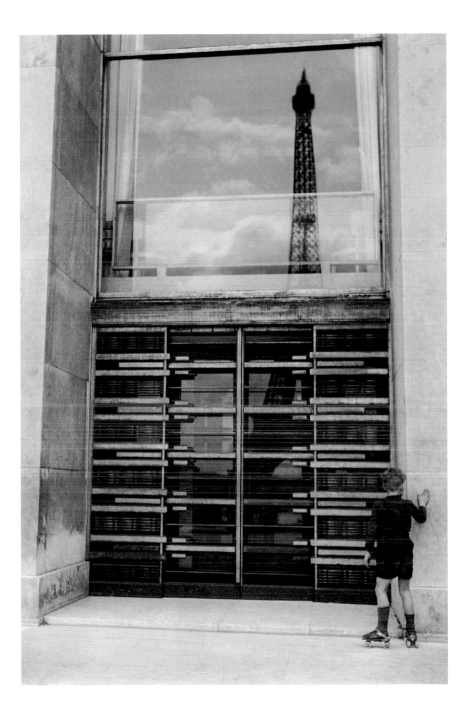

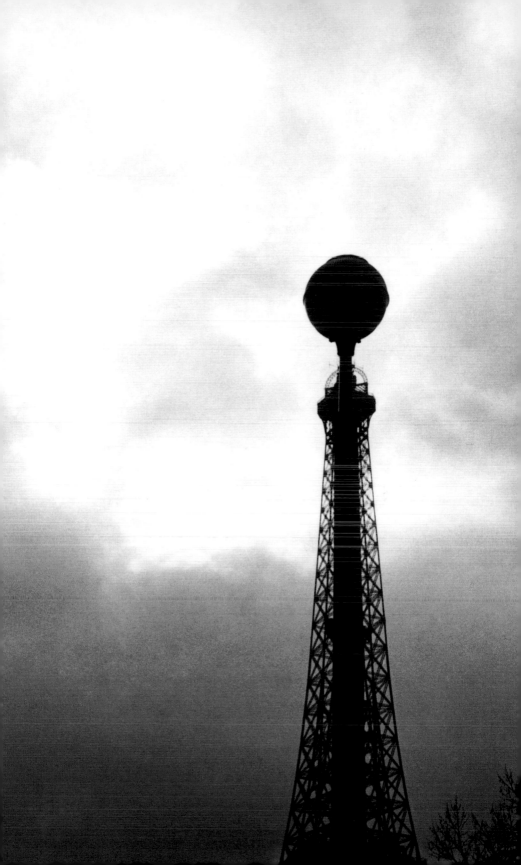

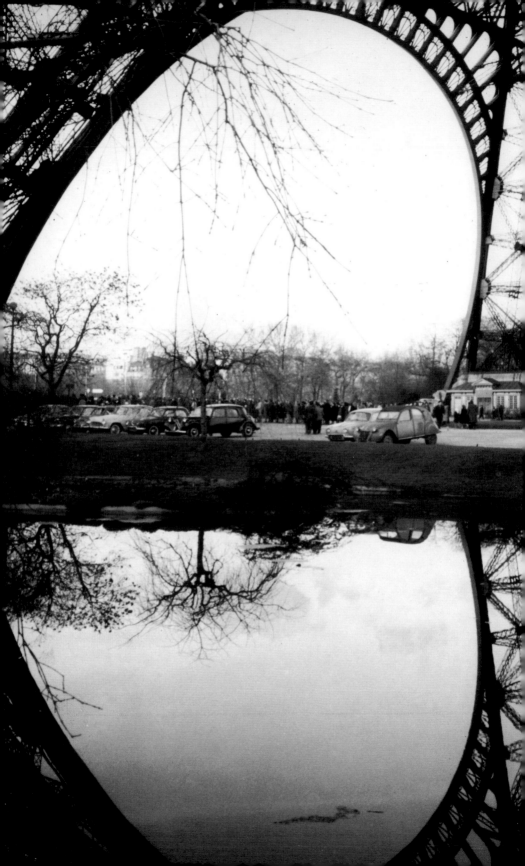

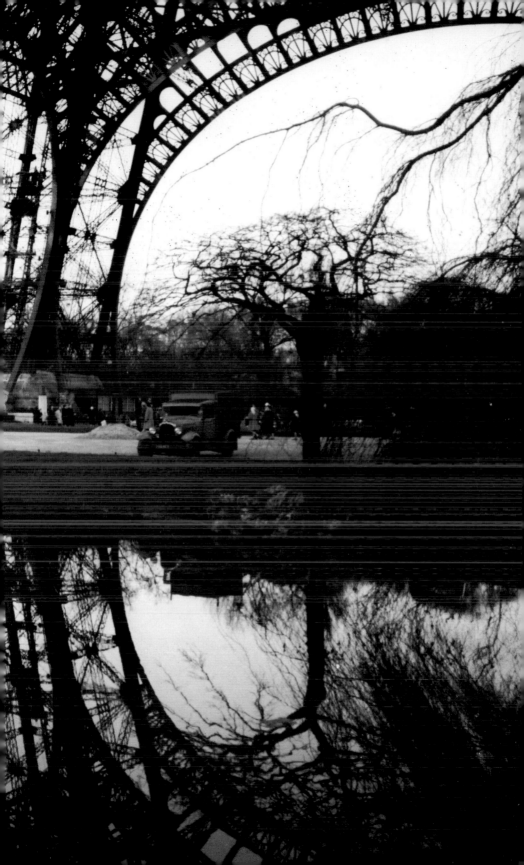

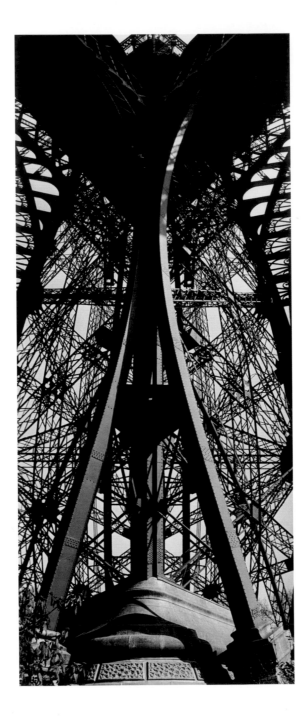

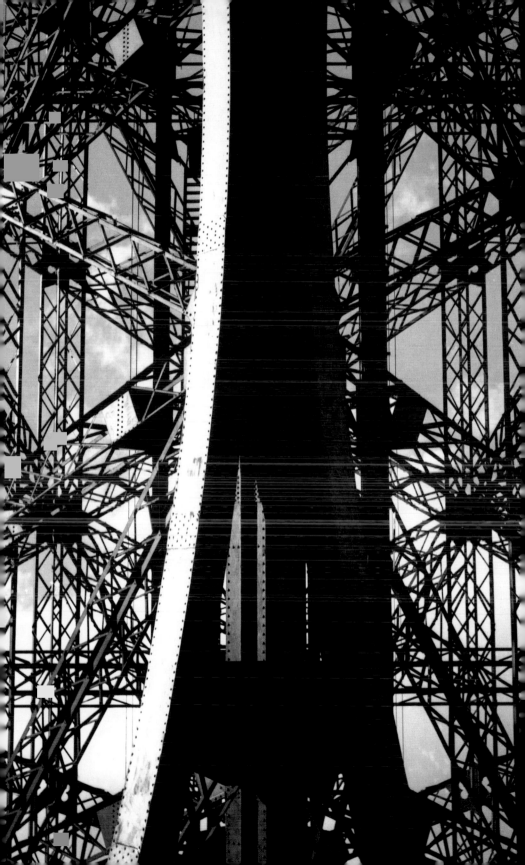

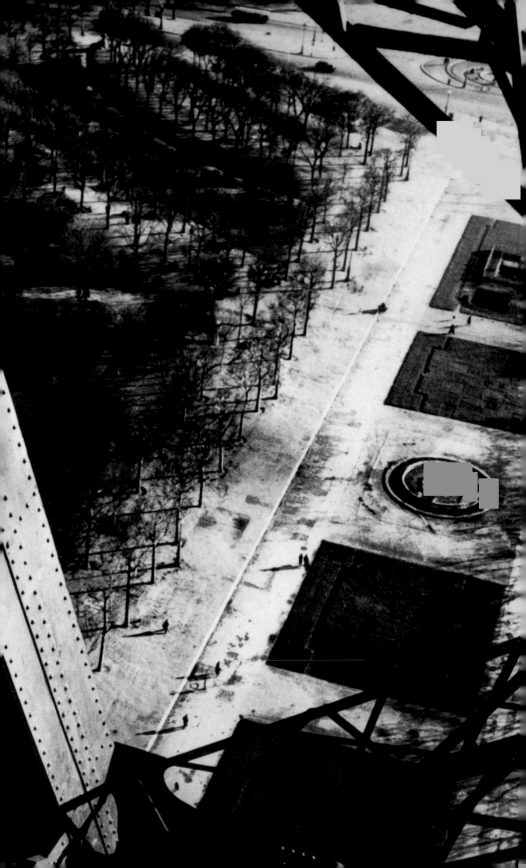

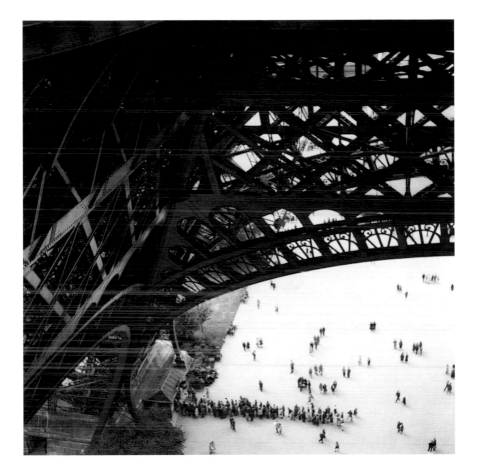

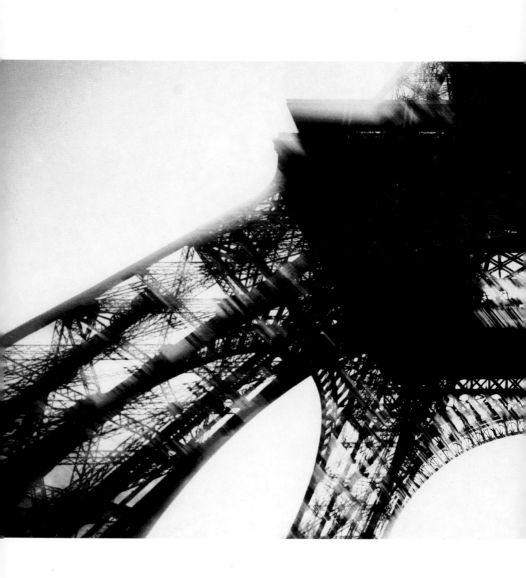

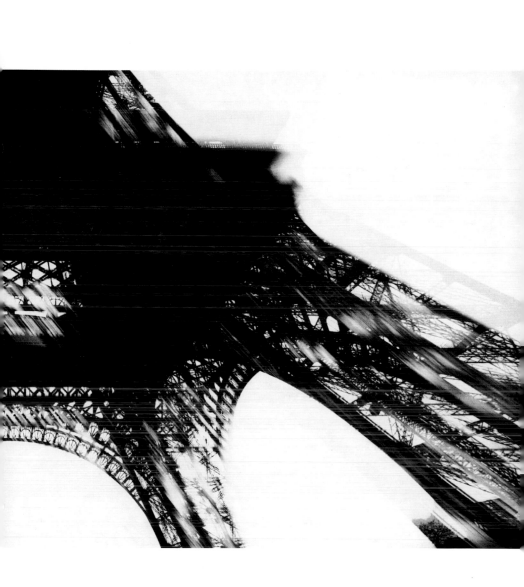

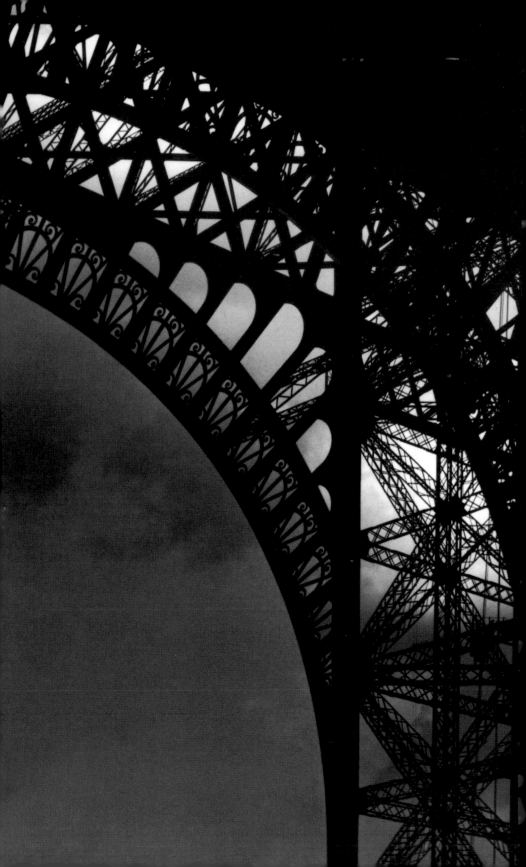

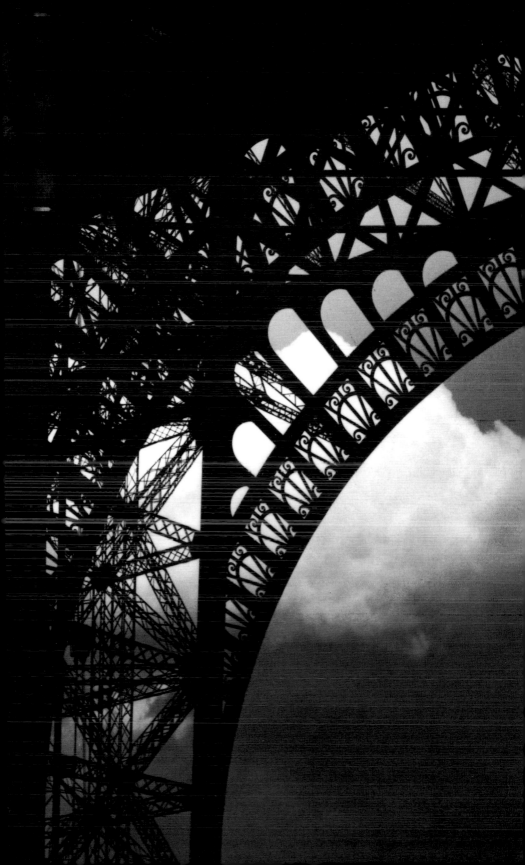

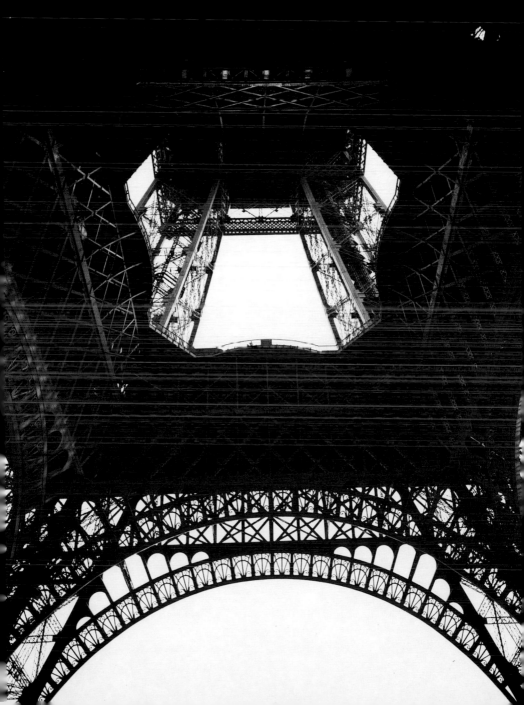

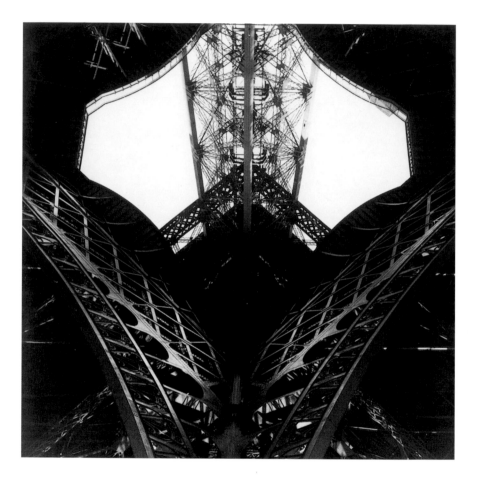

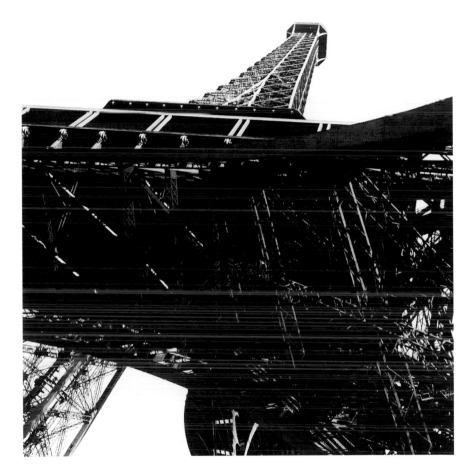

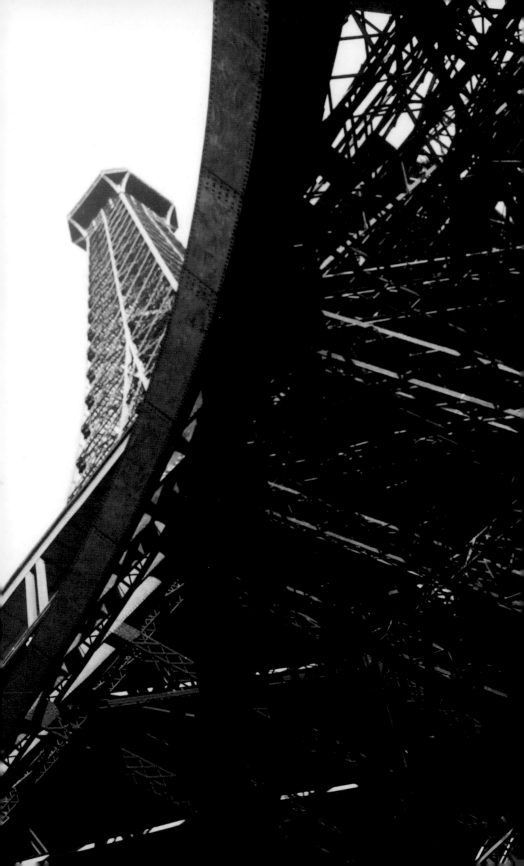

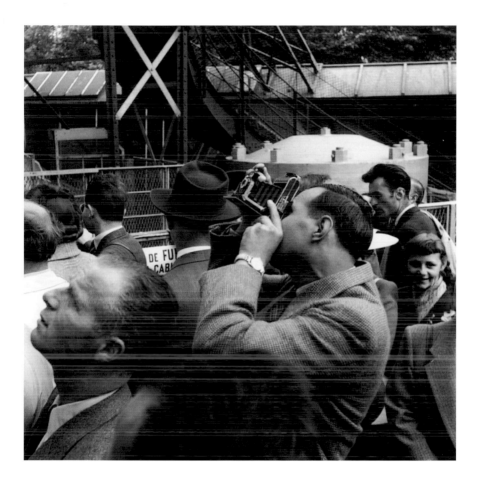

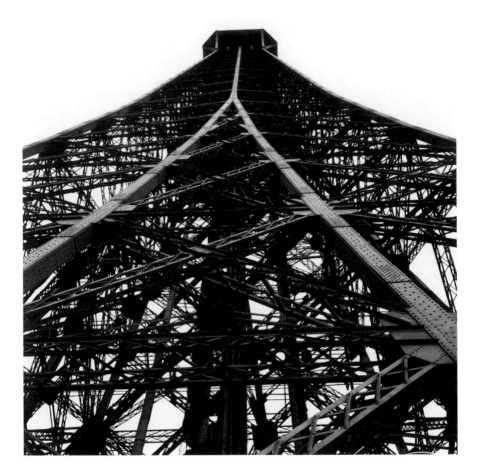

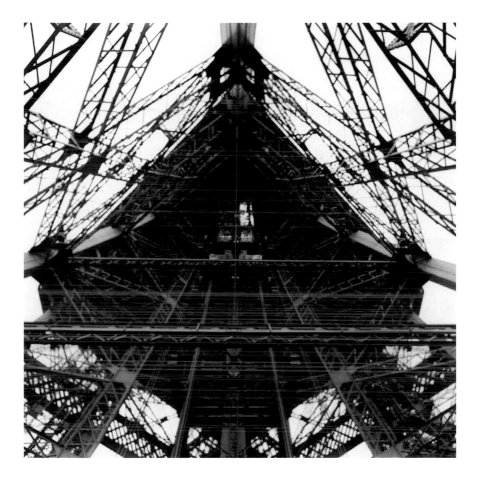

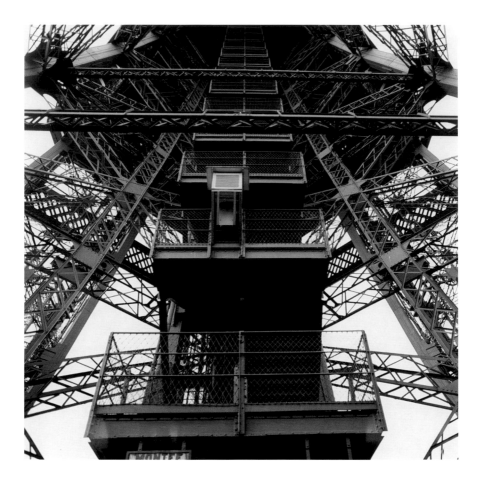

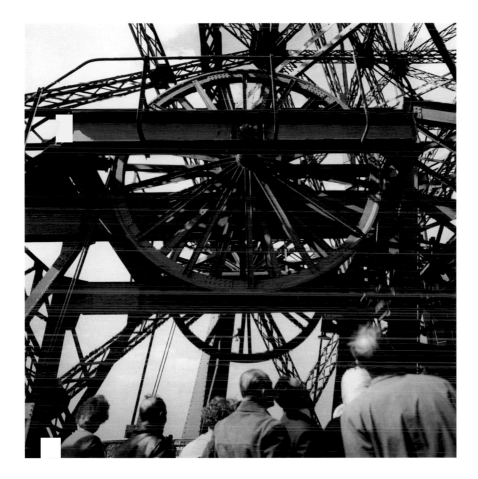

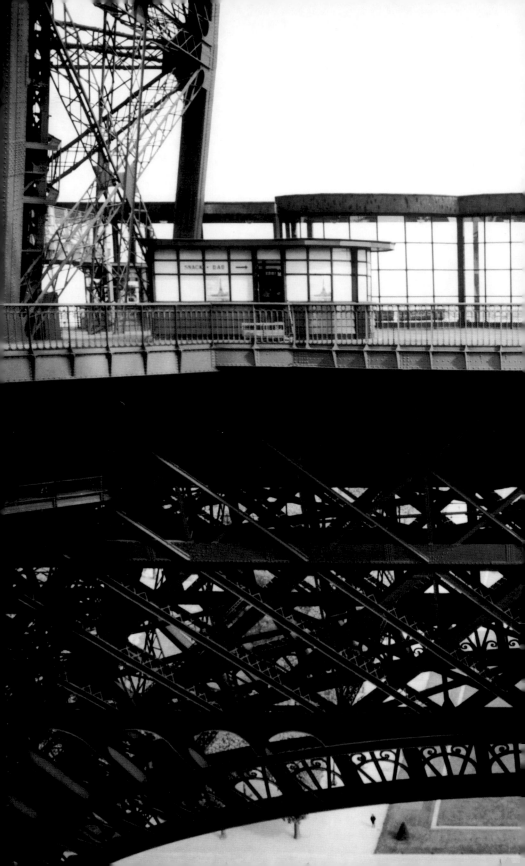

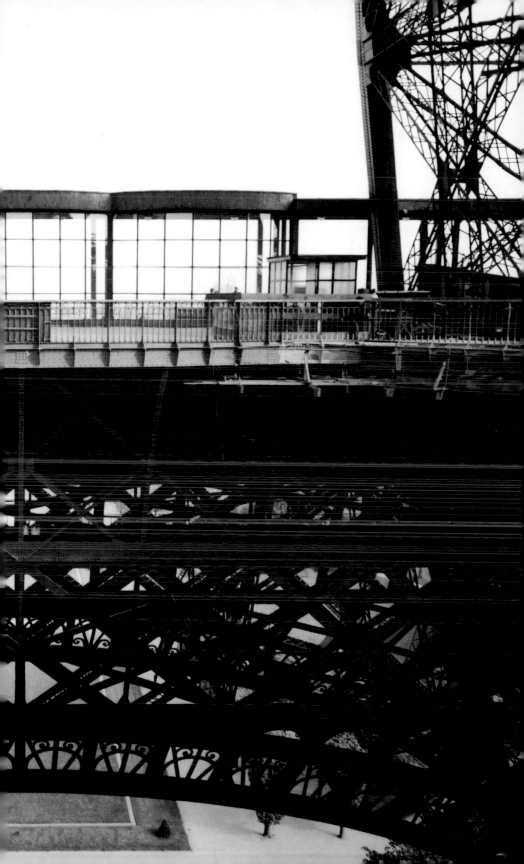

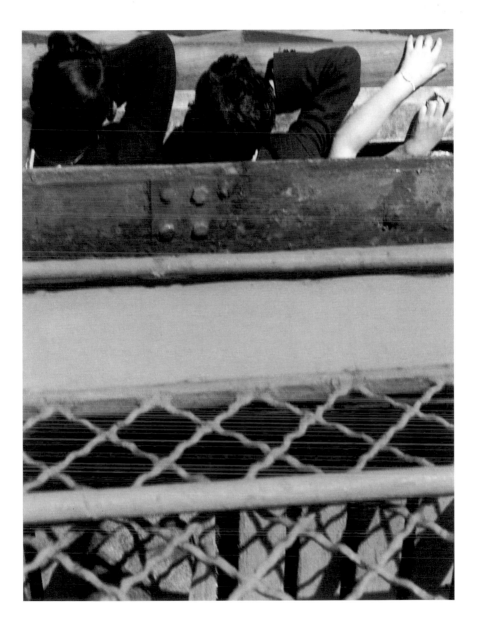

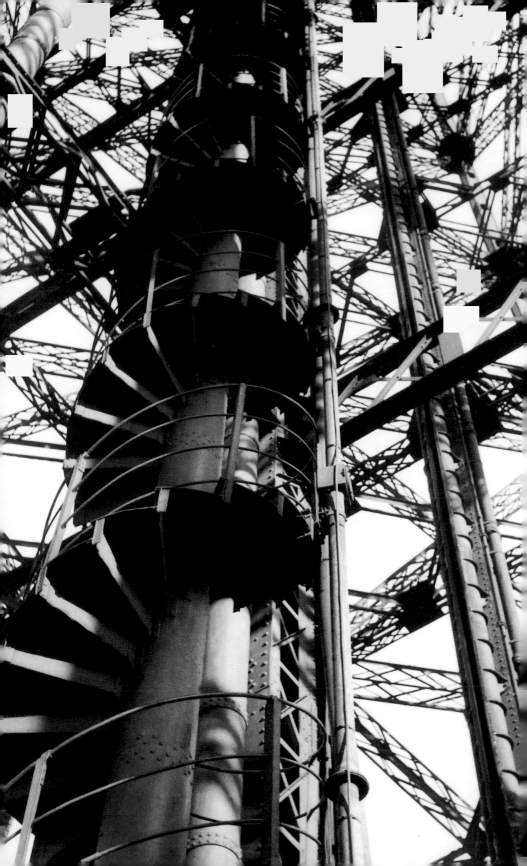

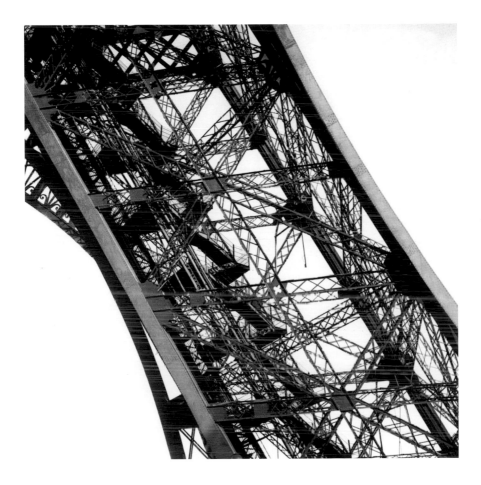

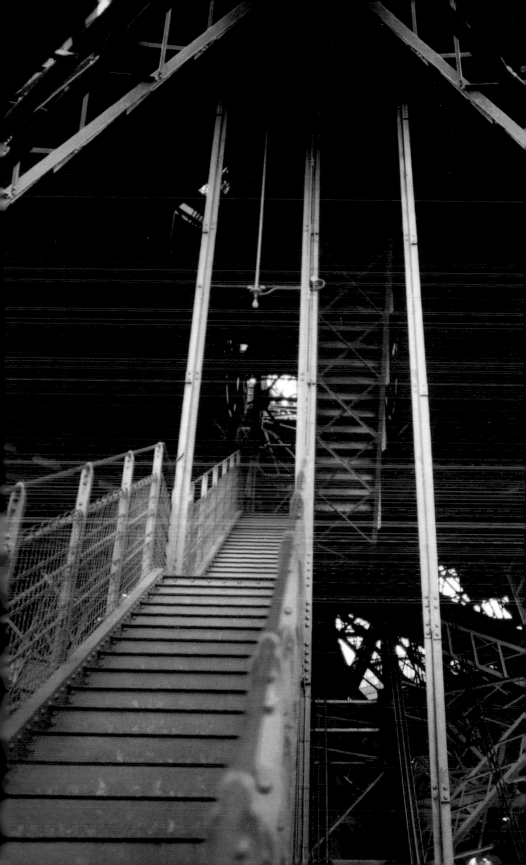

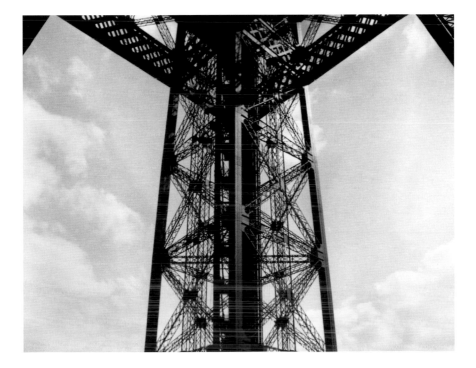

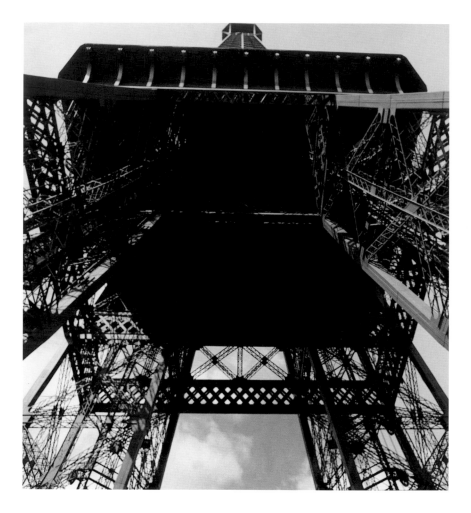

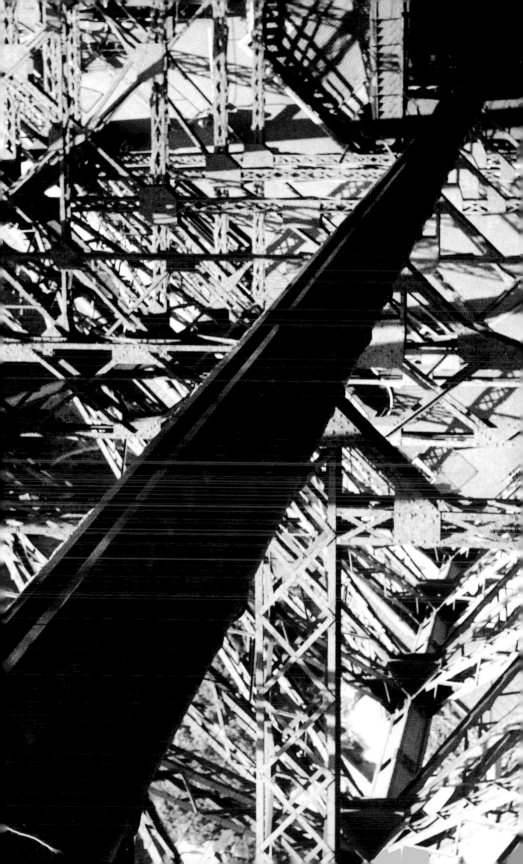

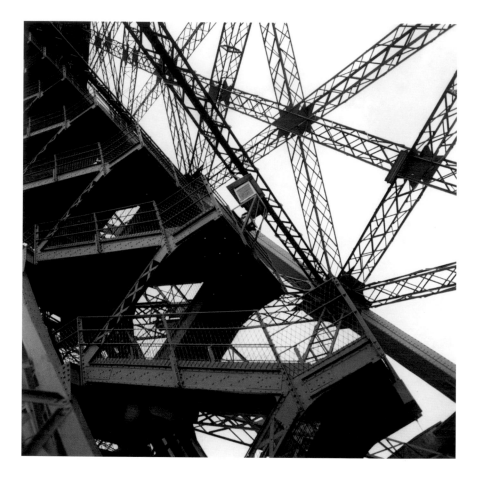

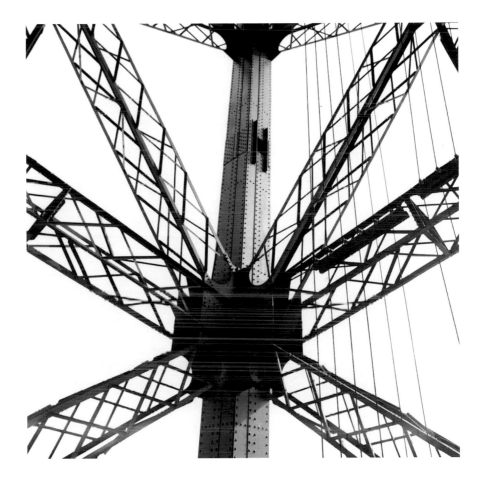

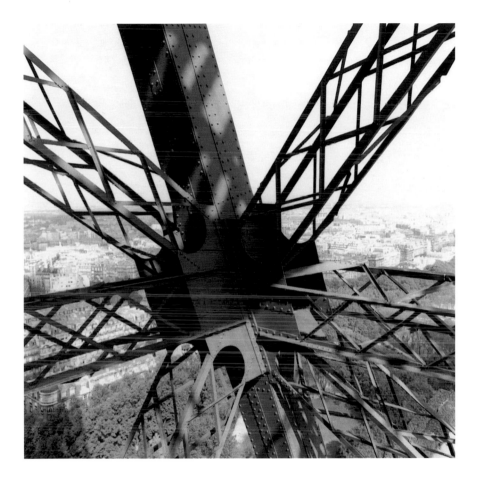

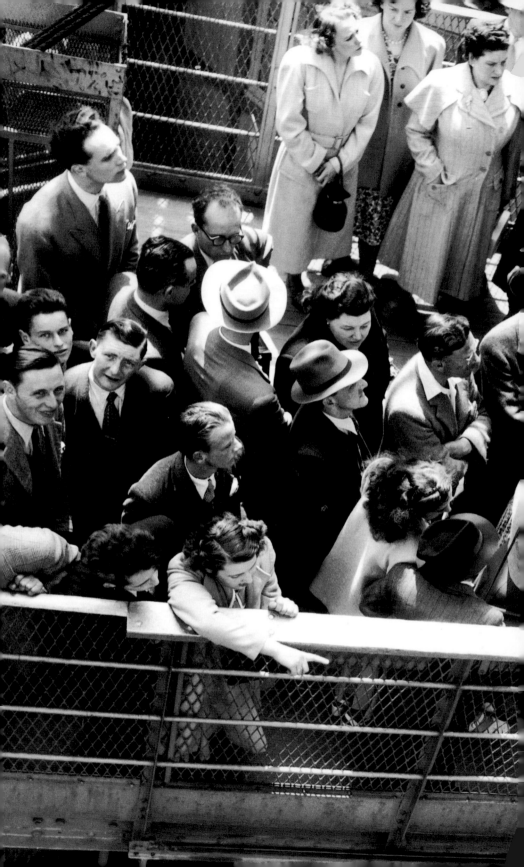

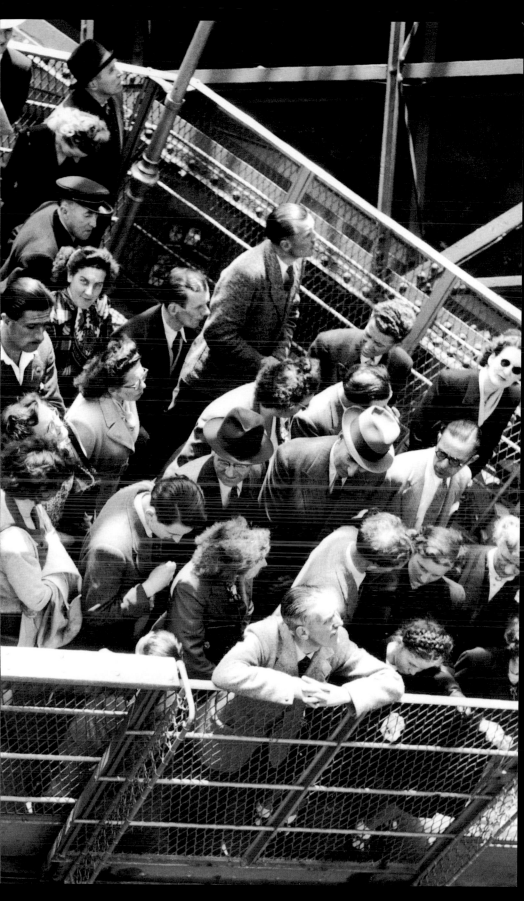

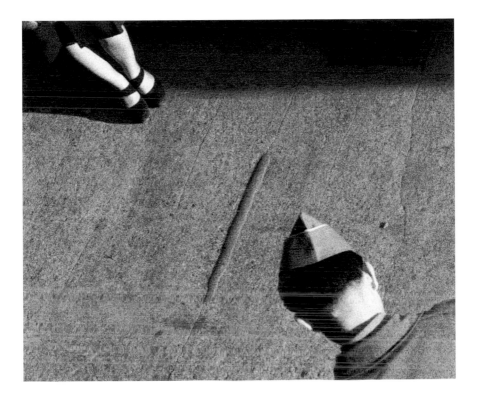

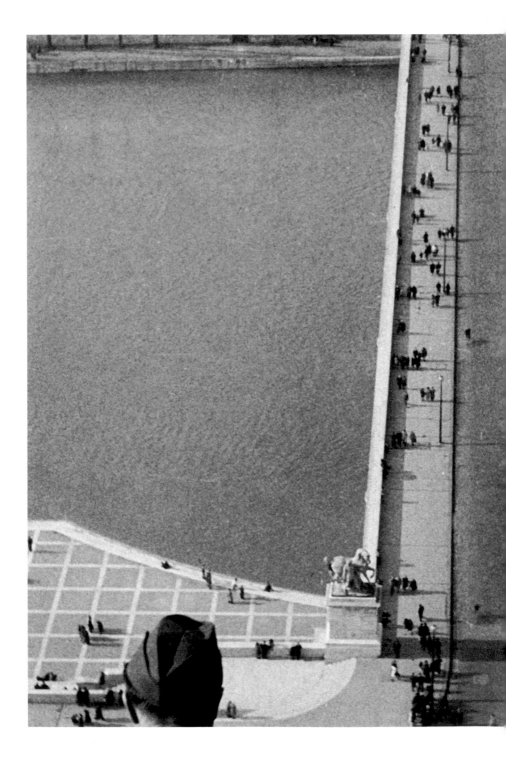

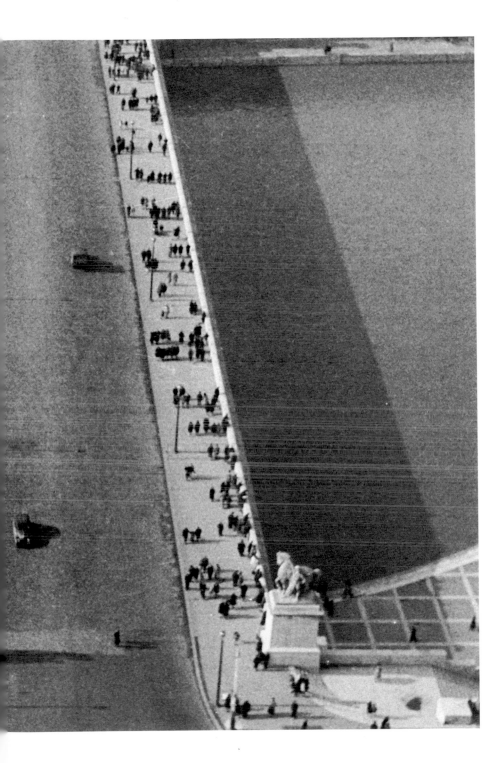

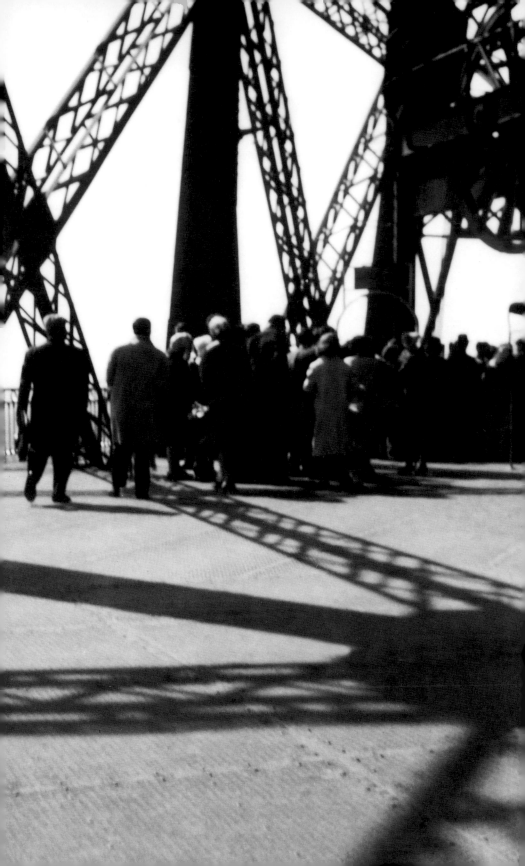

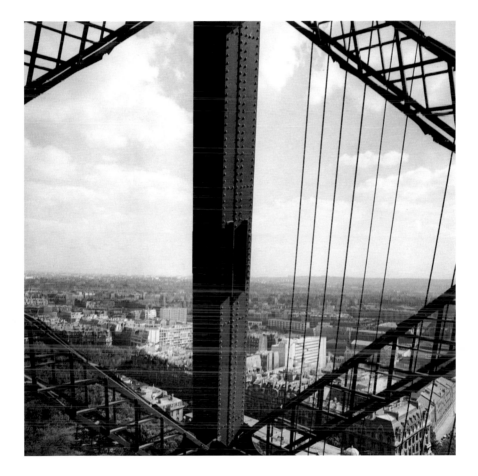

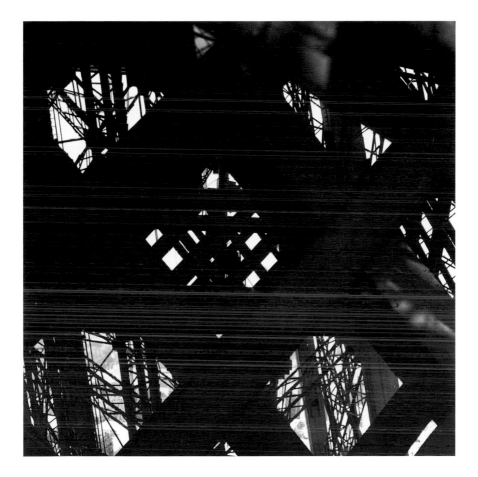

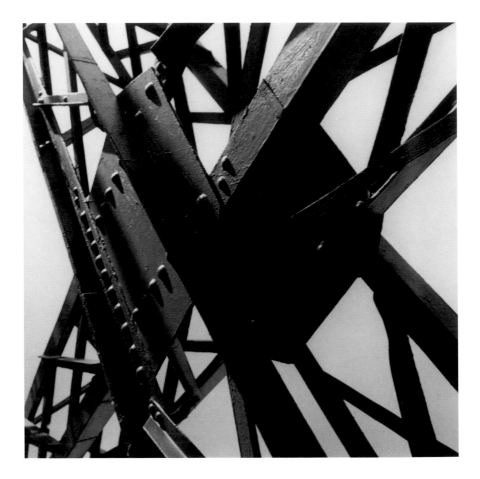

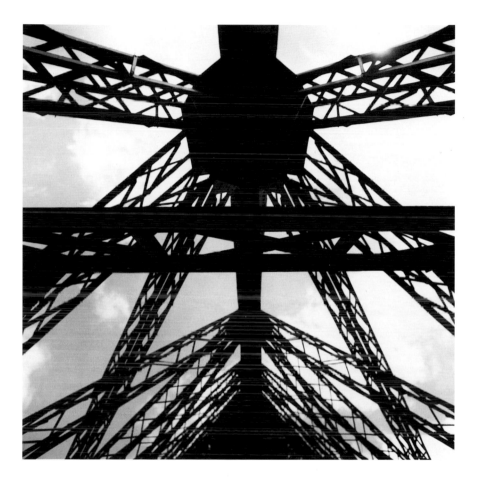

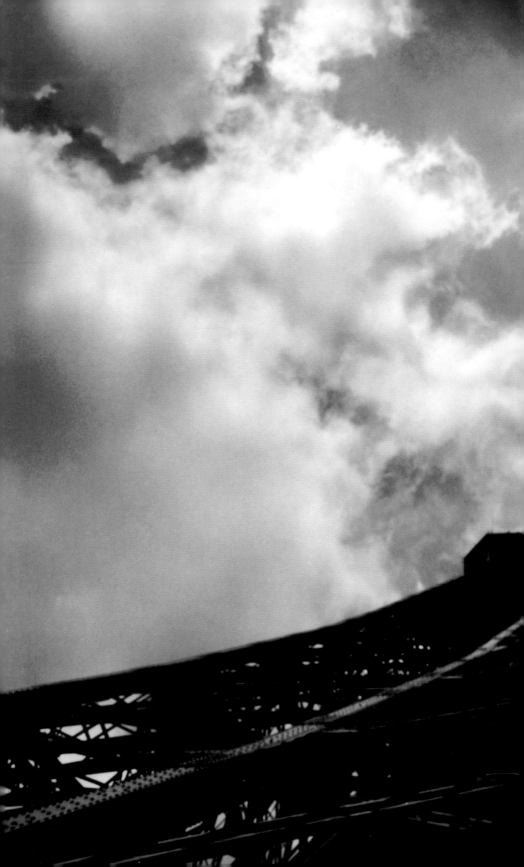

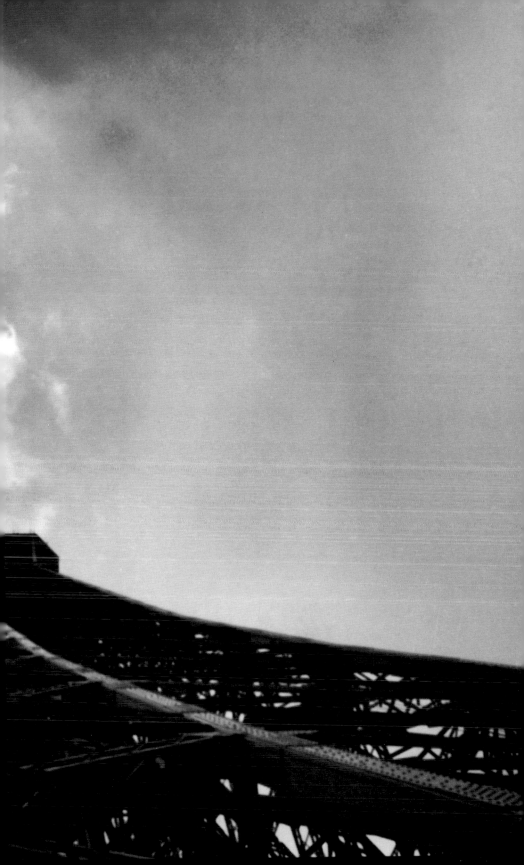

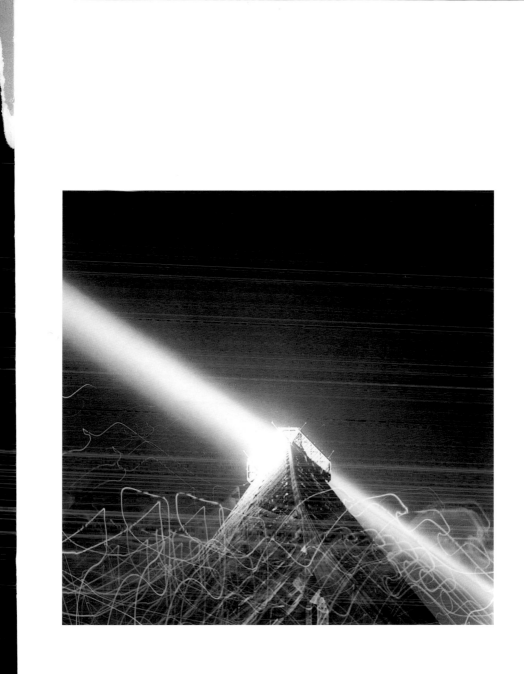

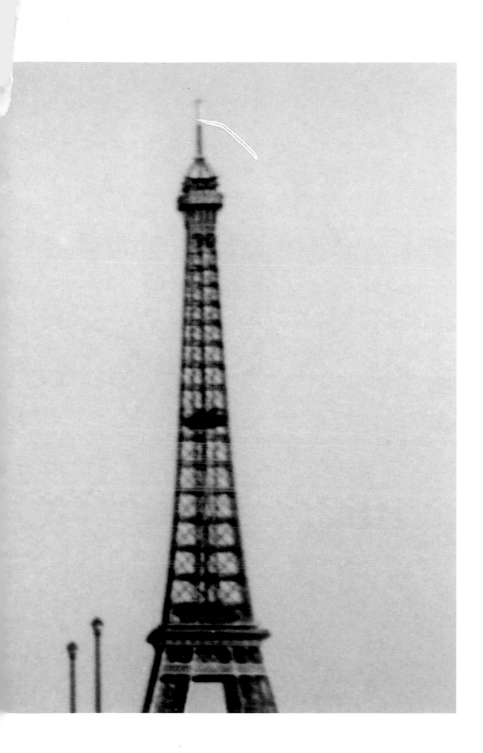

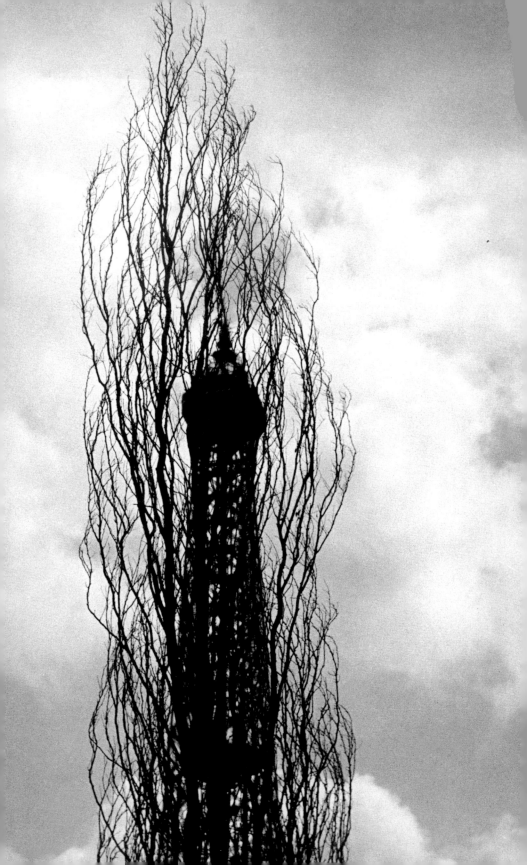

THE EIFFEL TOWER

BY THE NUMBERS

Inauguration: 31 March 1889

Construction time: 2 years, 2 months, 5 days

Workers killed during construction: 1

✳

Height: 300 meters (986 feet)

Steps: 1,665

Girders: 18,038

Rivets: 2.5 million

Paint: 50 tons every 7 years

✳

Annual visitors: 5 million

Total visitors since inauguration: 200 million

Visibility from top: 67 kilometers (42 miles)

Cost of a trip to the top by elevator: 9.90 euros

Cost if you walk: 3 euros

KEY TO IMAGES